MUSINGS OF BIRD
THE VOICES

TWISHA RAY

XpressPublishing
An Imprint of Notion Press

Old No. 38, New No. 6
McNichols Road, Chetpet
Chennai - 600 031

First Published by Notion Press 2020
Copyright © Twisha Ray 2020
All Rights Reserved.

ISBN 978-1-64805-248-4

This book has been published with all efforts taken to make the material error-free after the consent of the author. However, the author and the publisher do not assume and hereby disclaim any liability to any party for any loss, damage, or disruption caused by errors or omissions, whether such errors or omissions result from negligence, accident, or any other cause.

While every effort has been made to avoid any mistake or omission, this publication is being sold on the condition and understanding that neither the author nor the publishers or printers would be liable in any manner to any person by reason of any mistake or omission in this publication or for any action taken or omitted to be taken or advice rendered or accepted on the basis of this work. For any defect in printing or binding the publishers will be liable only to replace the defective copy by another copy of this work then available.

To my cr dadu, Maa ,Baba

Contents

Acknowledgements	*vii*
Prologue	*ix*
Disclaimer	*xi*
Regd. Under Msme Act.	*xiii*
1. Our India Our Duties	1
2. City Of Joy	2
3. Maa – The Power Of Hinduism	4
4. Focus For Goals	6
5. Angels Of My Life	7
6. Fun Of Months	9
7. Hatching Hens	10
8. Ila Dida	11
9. Woman's Inner Voice	12
10. 16 Th Feb 2018, 1:45 Pm	14
11. Life Without Internet	15
12. Joyous Day	16
13. Purity Of Life	17
14. Musings Of India	18
15. Cyber- This Days	20

Acknowledgements

The success and final outcome of this project required a lot of guidance and assistance from many people and I am extremely privileged to have got this all along the completion of my project. All that I have done is only due to such supervision and assistance and I would not forget to thank them and giving me and all support and guidance which made me complete the project duly. I am extremely thankful to my dear grand father for providing such a nice support and guidance, , till the completion of my work by encouraging me the right path of my life by providing all the necessary information for developing myself.I would not forget to my parent's contribution since birth to till now for their encouragement and more over for their timely support and guidance till the completion of our project work.I am thankful to and fortunate enough to get constant encouragement, support and guidance from all my teachers , friends which helped me in successfully completing my project work. Also, I would like to extend my gratefulness to my people who everyday inspires me to think about the society in a different way special way .

Prologue

India is a land of rich culture and heritage where people have humanity, tolerance, unity, secularism, strong social bond, and other good qualities. Indians are always famous for their mild and gentle behavior, in spite of lots of aggressive activities by the people of other religions. Indian people are always praises for their caring and calm nature without any change in their principles and ideals. India is a land of great legends where great people took birth and do lots of social works. They are still inspiring personality to us.

India is a land of rich culture and heritage where people have humanity, tolerance, unity, secularism, strong social bond, and other good qualities. Indians are always famous for their mild and gentle behavior, in spite of lots of aggressive activities by the people of other religions. Indian people are always praises for their caring and calm nature without any change in their principles and ideals. India is a land of great legends where great people took birth and do lots of social works. They are still inspiring personality to us.

Disclaimer

This is a work of fiction. Our editors have tried their best to edit the content of all the author/authors and check the plagiarism.

All the write-ups in this book are unique and are only published in this book.

In case any plagiarism or error is found, only the author is responsible alone, and not the publisher.

Regd. Under Msme Act.

Copyright, 2019, Twisha Ray

All Rights are reserved. No part of this book may be reproduced, stored in a retrieval system, or transmitted in any form by any means, electronic, mechanical, magnetic, optical, manual, photocopying, recording or otherwise, without the prior written consent of its writer.

1. Our India our duties

India is famous for its culture, literatures and spices,
but from some years it is facing some big crisis.
Many people's thoughts here is still orthodox,
And politicians here only know to do high talks.
The things for which our country today is known are only poverty and corruption,
Not for all around the country free and comolete education.
The political parties here just want in the parliament a seat,
And they never see that many people in the country has nothing at all to eat.
We have to today develop in many spheres,
And have to make sure the people herd for this country really cares.
My country is the one who has a great history,
But why everything is so expensive is a major mystery.
Our country has seen many great personalities,
Those were the only people who showed us the world's realities.
I also respect of my country's ethical cultures and traditions,
These are the secrets for improving our country's conditions.
India's best thing is it's people unity,
Can throw out any damaging material we all have such high immunity.
For the fact that I am an Indian I am really proud,
And this thing in front of everyone I can say out clear and loud.

2. City of Joy

The city of joy from where I belong
Is A Land of many faces
Of many creed, multiple colours
Many religions and various races
The slow pace of life here
Makes everyone stay at ease
Everyone enjoys afternoon siestas
All worries seem to cease
Down the roads the continuous tinkles
Of trams and many a hand pulled rickshaw
Seem like harmony to the ears
Like a symphony without any flaw
Hot tea in earthen clay pots
Along with masala puffed riceY
ou get them at every street you g
oAnd they taste really nice
Football crazy are the people here
They follow the sport like a religion
The talent resides in every kolkattan
yet he may belong to any other region
Monsoons arrive in thick black clouds
Smell of wet soil rises in the air
A season to set sail the paper boats
A Relief from the summer sun's glare
Autumn sows the seeds of Durga puja

The grandest celebration of all
The sound of the drums resound in the air
People dance and have a ball
The waters of the Ganges mark the end
Of the puja celebrations
The banks of the river mainly the ghats
Become centres of congregations
The food here is the main attraction
With all sorts of fishes galore
Mishti doi and roshogolla
Will make you pleading for more
A city which welcomes every single one
All people big and small
So many faces and numerous festivals
With Joy- the one emotion in all.

3. Maa – the power of Hinduism

Life like atomic light of Almighty,
It can't be burnt by the fire might.
From its separation to salvation,
In mind its journey sine qua non.
Time is prime factor of all action,
GOD can not show any reaction.
G of GOD for a term Generation,
O (Organization), D (Destruction).
Darkness must due to destruction.
Mother KALI shows darkest action.
Then little light in shape of the star,
Creation gets mother Star's power.
Gradually shape of mother different,
Yellow colour Ma SUBHDRA best.
Ma Hingula of red fire we worship,
White colour SARASWATI we see.
Beautiful look of Ma Bhabaneswari,
Always light is a symbol of victory.
Fire is centre of Sun sources light,
Sharing light the Moon serves night.
Kali Puja that is Worship of Ma Kali,
After that comes day of Deepabali.
Prior these 2 Durga puja Dushera,
Also Lakshmi puja at whole area.

Likely Saraswati Puja we observe,
Burning lamps our cultures preserve.
Mantra: Surya Jyoti ;Jyoti Surya namah
Next say Agini Jyoti Jyoti Agnih namah,
Last say Deep jyoti Jyoti deep namah,
Mata Parameswri Pita Parambrahmah.
Light in Vijaya Dasami Rama's Victory,
On the demon Mahisa Durga's Victory.
Diwali or Deepabali welcome to Rama,
Also previous forefathers high welcome.
They come their land through dark path,
We show them light to return in light path.
Spiritual Hindu colure is based on reasons,
Example is Six face of Kartika six seasons.
MAHAKAL Lord Shiva MAHAKLI his wife,
Worshiping mother Goddess liberty of life.

4. Focus for goals

Let's focus on something else.
Just enjoy your life.
I appreciate everything you do.
No sense of getting tuned up.
I don't want to hear anything you have to say.
Everything is not a game.
Why are you treating me like some kind of criminal?
I think you are evil.
I'm trying to help you out.
You are trying to take away my blessings.
I don't even want to be the boss.
I just want to be me.
I'm not trying to hurt your feelings.
Do right and you to would have stuff.
Instead of just hating on another person.
I'm getting sick and tired of this shit.
What did I do to you?
You act like you are so much better than me.
You being mad at me is not my problem.
That's God's issue

5. Angels of my life

They are my strength,
They give me courage,
They are my belief,
And help me during every voyage.
They are my first teachers,
They are my first admirers,
They are special to me,
And fulfilled whatever I desired.
They are my torch bearers,
They eradicate my confusion,
And if they are around,
There cannot be any illusion.
They forgive all my blunders,
They cured me of my vices,
And always taught me to help others and never be conceited.
They feel proud on my success,
They feel sad on my failure,
They admire me on my achievement,
And console me on the right path of life
Their care for me is intense,
They feel pain for me even on a minor scratch.
Though they don't know whether,
I would help them or would be a brat.
They cut their saving for my expenses,
They forget their luxury for my comfort.

They sacrifices are uncountable,
And are a debt, which is unpayable.
They feed us though they are starving.
They make me smile though they are sad.
They give me all though they have nothing.
I want to be their devotee and want their blessings.
Parents like those are hard to find,
I am very lucky to have such kind.
They are a gift which is divine,
They are as "God Visible", for mine.
Even devoting my life to them would not do.
I can't even think of their substitute on earth.
I only pray to be their child, Whenever I take birth.

6. Fun of Months

Let's have some fruits and curry
Year has started with January
Oh my dear, please don't worry
After this will come February
Let's ready with the biggest torch
Because darkness will be in March
Some hotness, we can feel
In the month of April
Let's ready to swim in bay
It will come hottest May
We will be happy soon
Rain will be there in June
We have to help the places fully
Because there will be floodish July
We have to clean the door dust
Then it will be happy August
Let's help our family member
In the month of September
Please give the gift of rubber
In the cold month, October
Let's clean our home chamber
In the month of November
Please find out the great plumber
Because it will the coolest December

7. Hatching Hens

Hens sit clucking, awaiting
Arrival of their precious chicks
Their bedding soft, their owners
Caring; readying for chicks to
Hatch one by one, then
Incubating the fluff balls
Not allowing them to freeze
Growing slowly every day
Eggs are born from hens
Gracious little fluffy babes..
Gus carefully collects the chicks:
Sir, that's not a hen!

8. ILA Dida

Grandma
I hear your voice so clearly
your hope
that see's me for me
you always knew
that my journey
was meant to be
even when others
wouldn't
you found that way to encourage me
even when the road was hard
your solace
allowed me to keep going
your wisdom
showed me which path to take
your love
smiles down on me
I hear your whispers
telling me
keep on going
and believe
within the truth
in your heart

9. Woman's inner voice

The voice can be heard silently
singing pacifying lullabies to the angels.
Through out the ruptured home it roams
as the wind fiercely blows out the candles.
Thunder plays along with her cold fingers
the repetitions of the piano keys very meek.
They lived happily ever after is dead here
as this fairy tale begins to grow more weak.
With each passing movement of her fingers
the charcoal black skies begin to reappear.
Tension rises then falls with the lightning
the feeling of safeness quickly disappears.
She looks back at her past and that night
when her family brought her to her death.
She vows that revenge will soon be hers
faith can't stop her until their last breaths.
For God has taken her under his gold wings
though redemption seems far more sweet.
As she drops down from Heaven clipped
Hells doors she will soon come to and greet.
Yet the notes become heavier and faster
The windows of the house shatter and fly.
Her eyes become darker and more cold
as the memory of her favorite piano dies.
As her blood stains the floor beneath her

she knows the Devil gave her one last test.
For her soul is his and their lives will be hers
but will doing this lay her peacefully to rest?

10. 16 th Feb 2018, 1:45 PM

From up here they could all be forgiven
Separated as I am from their spite
My nostrils free of their smells
My ears free of their whines and grunts

I look up at the greying clouds
And in wishing I could be up there
I'm suddenly back amongst them
And I feel.. nothing but contempt
Their silence feels like a scream to me
The looks they give, like spit on my skin
I'm ripping apart, unravelling
I don't know how to act anymore
How many more will they do this too
Then it hits me, these people...
Perhaps one day after a long life
A life of using and abusing others
They'll find happiness
And it disgusts me...
...and I can't live with that

11. Life without internet

Well Internet! you have become so close a friend.
That our life has now got just a fixed easy trend.
And if internet is vanished for a day or so
We are heard saying 'this awesome task how will we do?'
It is still horrible to imagine this lethal extreme;
that internet has gone for a year for some reason unseen.
People might dump in rivers their mobile phones;
For they wouldn't get any email from known friends or unknown.
The viruses will die there and worms will feel suffocated
The hackers will be unemployed and websites aborted.
Some might find relief thought, for they were disappointed
Looking commercials in websites they were feeling targated.
Sending emails and attachments they had become so busy
Ignored wives and children often appeared dizzy.
The garbage market will get a boom by thrown away internet modem.
The grandparent will tell this tale to remove children's boredom.
And when one day an envelop will fall in their doorstep
They will virtually jump ahead to read if it will fill the gap.

12. Joyous day

Unfurl the tricolor of India high!
Let love of Motherland ascend the sky!
Let's sing the national song by heart with pride!
Let's put away our differences aside!
Born are all Indians on this sacred soil;
For integration, we must always toil;
We brethren breathe the freedom's air today;
Unanimously 'Jai Hind', let's all say!
Remember lives lost, sacrifices done;
All states receive the same air, rain and sun;
Renew our pledge to guard our borders long;
With much respect, let's sing our national song!
We're proud to be called Indians upon earth;
We love to live in peace and spread out mirth;
No one can break our bond of Indianness;
We're poised to brave life's storms with much finesse.
Jai Hind! Jai Bharat!

13. Purity of Life

Each one of us, male or female
is imperfect and latent with frailty,
for that is a Higher Power's intent for us all,
yet women have been belovedly anointed
to accept and cherish His desired will for them.
A woman is the inception of compassion;
dutifully chosen to embrace and implement it
with the totality of selflessness and humility.
She is more than a benefactor of goodness,
she has been bequeathed as the bearer of it.
A woman is a man's treasured gift to him
and she accepts that this is her obligation,
for she is not superior to any man,
only chosen for the betterment of them all.
A woman is a symbol of purity,
for that is her delivered birth right;
to inoculate those she truly loves
with a vaccination of hope's cleansing
to all souls she permeates her heart out to

14. Musings of India

India has a beautiful
Culture & Heritage,
From Red fort to Ramayana
written by Valmiki sage.
India has beautiful
Tajmahal in Agra,
& is popular in dances
like Kathak & Bhangra.
India is famous for
Basmati rice,
Which is very
tasty & nice.
India's daily food
is Dal-Roti,
And village people
generally wear kurta-dhoti.
Indian women wear
suits & saris,
And one can find
Many unsung stories history of places
Each Indian knows their mother tongue
All Indians live in unity,
& it's a great beauty!
So visit my country INDIA,

It's one of the most cultured
 Country in Asia!!

15. Cyber- this days

Cybercrime
is haunting young people,
all the time, all the time,
never giving them a rest.
Cybercrime is a cancer.
Cybercrime is a pest.
Poison on a computerscreen.
The worst thing I've ever seen.
Young people like to share
the most intimate bits of information.
Surfing the net is their passion
and exchanging pictures is a fashion.
It happens in every country,
in every nation,
in every sort of way,
all day.
What they don't realise
is that there's a danger
when pictures and personal stuff
can be seen on the screen
by a stranger.
The kind of people I despise
will make their lives a living hell.
They are so embarassed,
they are so ashamed

that they're afraid to tell
and so it goes on and on.
When no one does anything to stop them
these cybernet villains have won.
Healthy young girls
who were once so vibrant and cheerful
become a shadow of themselves,
desperate, depressed, tearful.
They scream and shout
but don't see a way out.
More then often it ends with death.
Cybercrime killers see it as a game.
They like to threaten, they like to toy
with a picture, a face, a name.
They don't care who they destroy.
I think it's time for worldwide wrath.
Even when a victim survives
it's one of so many ruined lives.
Cybercrimes left them with wounds and scars.
Each villain committing a cybercrime
should end up behind bars
and do hard time!

www.ingramcontent.com/pod-product-compliance
Lightning Source LLC
Chambersburg PA
CBHW020715180526
45163CB00008B/3092